BIDEFORD

HISTORY TOUR

First published 2016

Amberley Publishing
The Hill, Stroud,
Gloucestershire, GL5 4EP
www.amberley-books.com

Copyright © Peter Christie & Graham
Hobbs, 2016
Map contains Ordnance Survey data
© Crown copyright and database right
[2016]

The right of Peter Christie & Graham
Hobbs to be identified as the Authors
of this work has been asserted in
accordance with the Copyrights,
Designs and Patents Act 1988.

ISBN 978 1 4456 5699 1 (print)
ISBN 978 1 4456 5700 4 (ebook)

British Library Cataloguing in
Publication Data.
A catalogue record for this book is
available from the British Library.

Typesetting by Amberley Publishing.
Printed in Great Britain.

INTRODUCTION

Bideford is an historic town with a proud history and many books have been written about it, but anyone who really wants to grasp the reality of its past needs to walk around its streets and lanes. Buildings are the tangible remnants of our heritage, created by our ancestors they each have a story to tell – from our beautiful Long Bridge to the eighteenth century merchant houses in Bridgeland Street. It isn't all about such grand structures, however, everyday houses and shops all have played a part in creating the town we know today.

This small book is an effort to guide and inform both locals and visitors alike around some of the interesting parts of Bideford. It cannot, of course, cover every building but anyone following our route should learn something of the town they live in or are visiting. One thing that has become clear is that Bideford has experienced just as many changes as other small towns throughout Britain. Businesses have come and gone while buildings have been remodelled to cater for new needs. Not all of these changes have been welcomed but history never stands still and what might have been seen as a vulgar new addition to the streetscape when built has now, with the passing of the years, become a much loved structure.

We are very aware that what we write today could be overtaken by events very quickly, but at least by providing archive photographs showing what used to be there a contemporary viewer can compare what they see with what once stood there.

Bideford was lucky to escape the worst excesses of the 1960s for the most part and it still has the feel of a smallish market and port town with the occasional breathtaking vista – where else can you see ocean-going vessels bobbing at the end of a High Street? Recent government diktats have ordered that Bideford accommodates 4,000 new houses over the next twenty years which means the town will change again; whether for the better or worse is impossible to tell, but whatever happens the historic core of the town will remain. This book is a guide to some of that history – we hope you enjoy it.

Peter Christie & Graham Hobbs

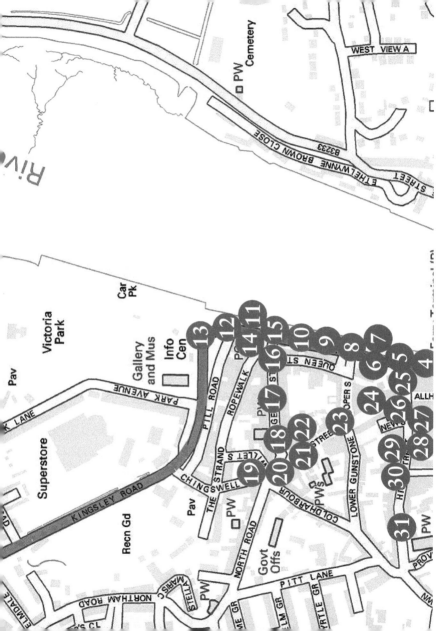

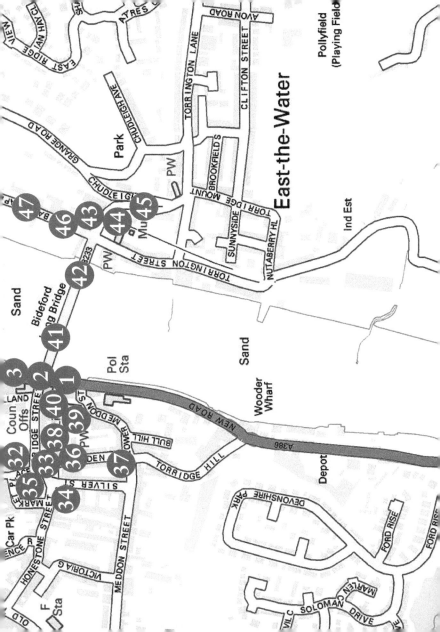

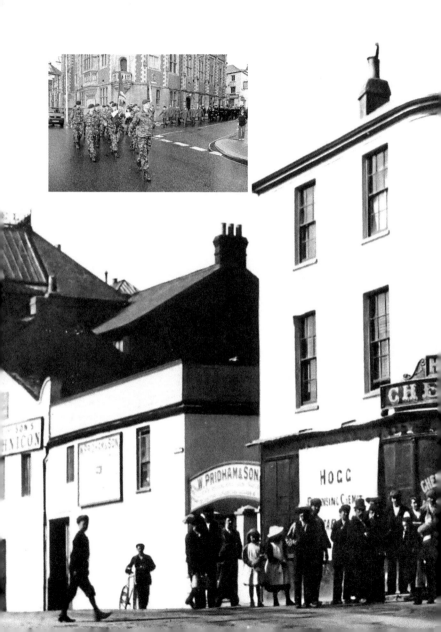

1. HOGG'S CORNER

Locally known as Hogg's Corner after the chemist's shop that was here for much of the nineteenth century, this has been greatly changed. For many years the town council wanted to expand the Town Hall (built 1850–51) and in 1906 they finally completed the new extension plus a new library, both of which are seen in the inset, which also shows detachments of local youth organisations marching past on a civic occasion in 2010.

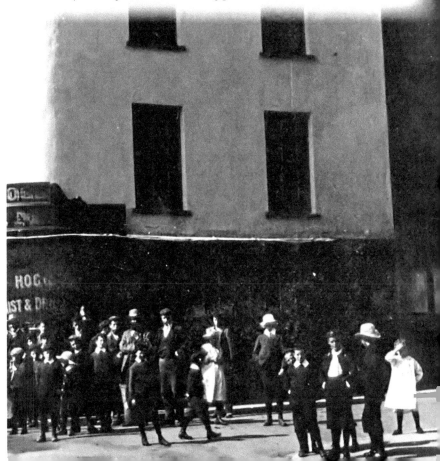

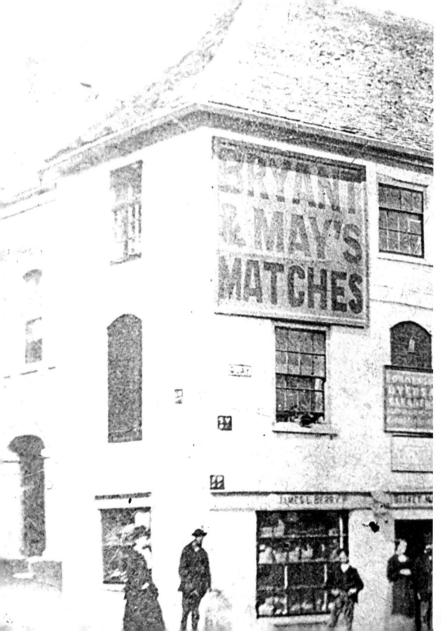

2. BRIDGE BUILDINGS

This image dates from sometime before 1882 when the Bridge Buildings were built by the Bridge Trust. The building to the left in the photograph was the Town Hall/Grammar School while the building to the right has been replaced by a block of three shops. The very ornate gas lamp has long gone but the stubby pillar it stood on is still present. The massive Bridge Buildings were sold for a purely nominal sum to Torridge District Council.

3. THE QUAY I

This photograph is one of the earliest ion record, dating, we believe, to pre-March 1857. The narrowness of the quay might surprise modern visitors, who would see the scene in the inset image. Quite a few of the buildings are still recognisable today and the plastic cladding to the one in the centre indicates that change is still continuing. When the trees were planted in the 1890s many complained that their presence would destroy the port business.

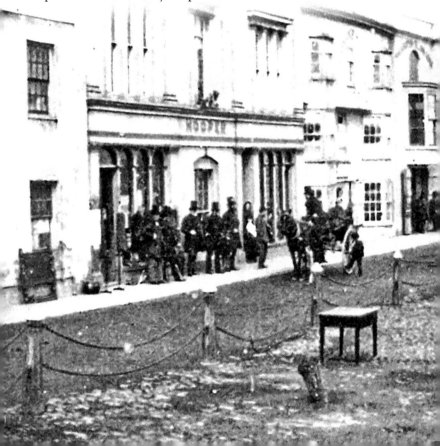

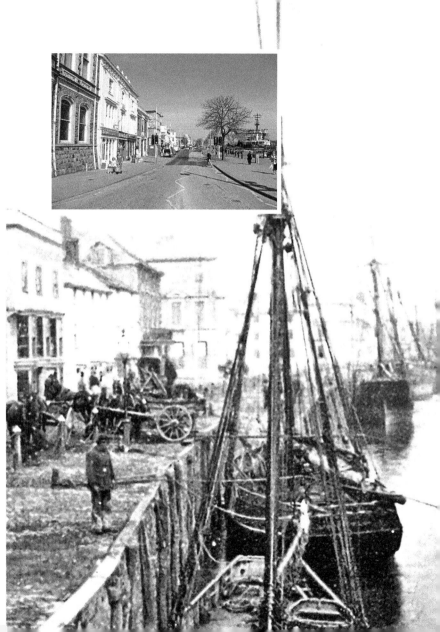

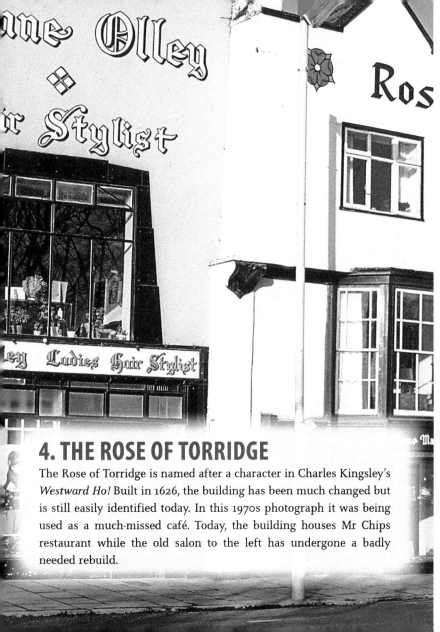

4. THE ROSE OF TORRIDGE

The Rose of Torridge is named after a character in Charles Kingsley's *Westward Ho!* Built in 1626, the building has been much changed but is still easily identified today. In this 1970s photograph it was being used as a much-missed café. Today, the building houses Mr Chips restaurant while the old salon to the left has undergone a badly needed rebuild.

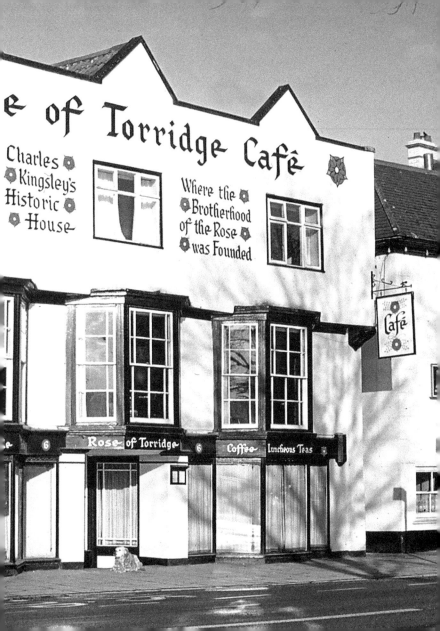

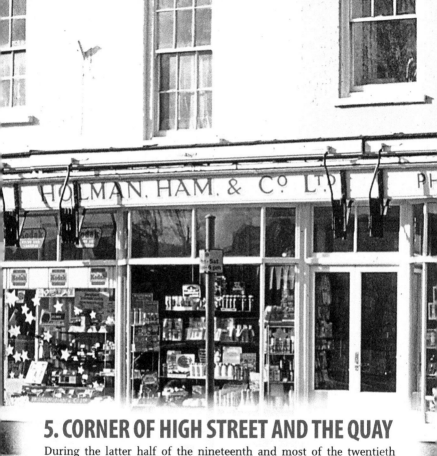

5. CORNER OF HIGH STREET AND THE QUAY

During the latter half of the nineteenth and most of the twentieth century the corner of High Street and the quay housed a chemist's shop. This image, dating from the 1960s, shows the crowded windows of Holman, Ham & Co., which has given way to a modern café. Note the odd-looking stone at the right – possibly the 'tome stone' referred to in sixteenth-century documents where Bideford merchants sealed deals by putting cash on the top of the stone.

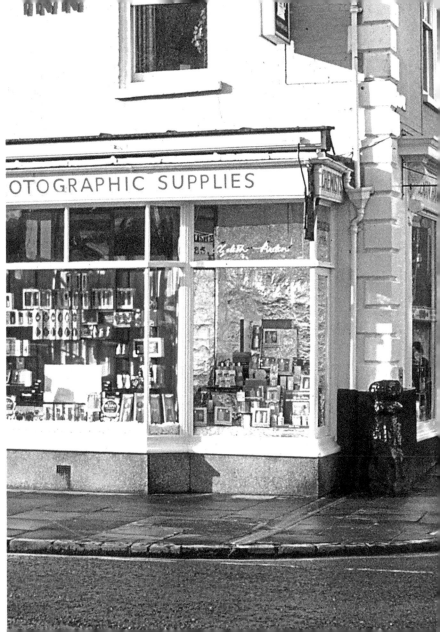

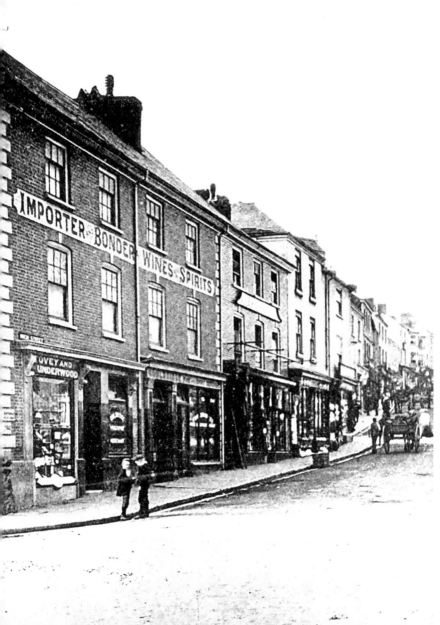

6. HIGH STREET I

The bottom of High Street pictured in around 1900. The street is at its widest at this point and was probably the site of the earliest market. Indeed, there is a record that the market moved from here in the seventeenth century. The buildings are still recognisable today, even if the shop fronts and their contents have greatly changed.

RICHMOND HOUSE

HOT WA...
& AGRICULTU...
ENGINEER...
PLUMBER.
SMITH.
BELL HANGER &...
...
RANG...
MANUFACT...

...URNISHING
IRONMONGER
OIL & METAL
MERCHANT
AGRICULTURAL
IMPLEMENTS

FISHING TACKLE
AMMUNITION
DEALER

This picture shows the large building on the quay with King Street behind. Back in 1900 when the photograph was taken, James Lewis was running a well-stocked hardware store in the small shop at the end. Radford's news agency is now in this shop with a cake shop and a florist's being found on either side of the still ornate door.

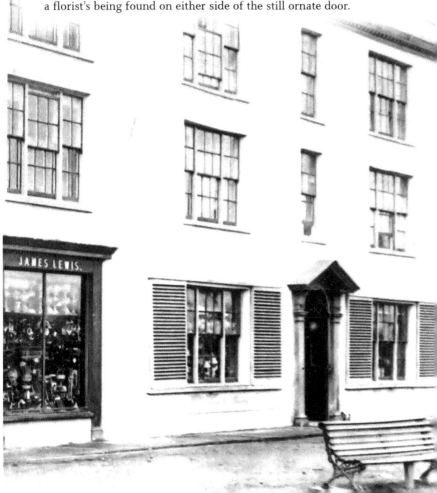

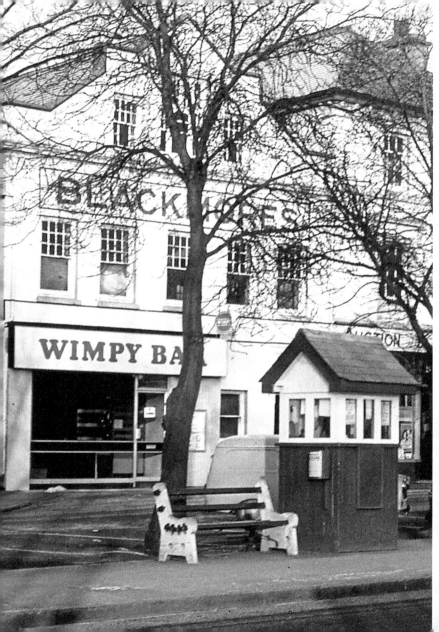

8. JUBILEE SQUARE AND THE MANOR CAR PARK

This image dates from the early 1970s and shows a very different range of street furniture to what is there today. The old telephone boxes, seats and lamppost have been replaced with a stainless steel rubbish bin, a bus stop and a modern lamppost. Another thing that has disappeared is the 'light up' map on the extreme right that used to delight children who loved to push its buttons.

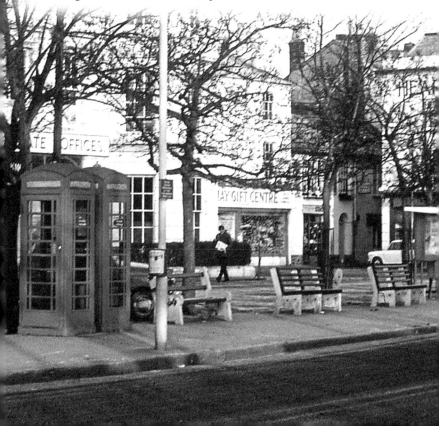

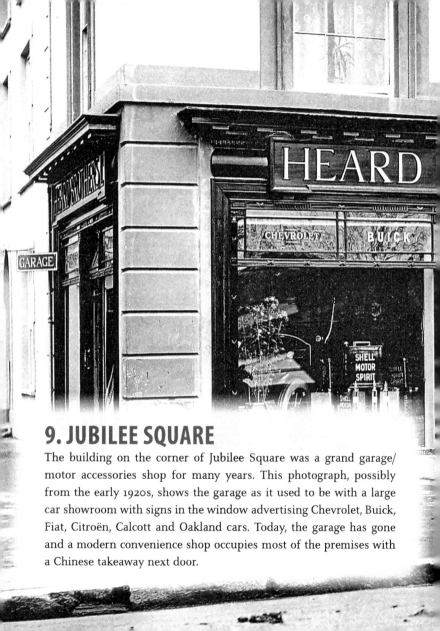

9. JUBILEE SQUARE

The building on the corner of Jubilee Square was a grand garage/motor accessories shop for many years. This photograph, possibly from the early 1920s, shows the garage as it used to be with a large car showroom with signs in the window advertising Chevrolet, Buick, Fiat, Citroën, Calcott and Oakland cars. Today, the garage has gone and a modern convenience shop occupies most of the premises with a Chinese takeaway next door.

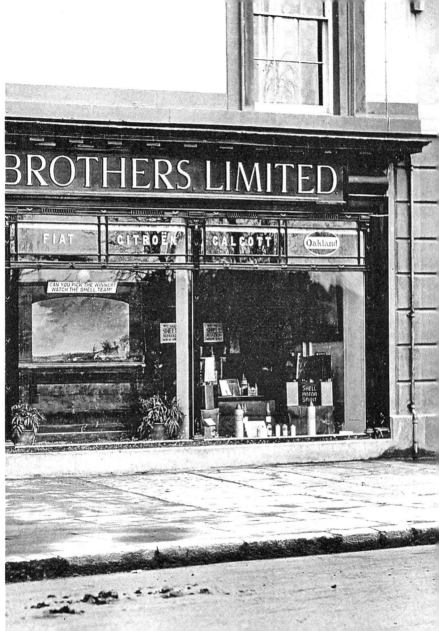

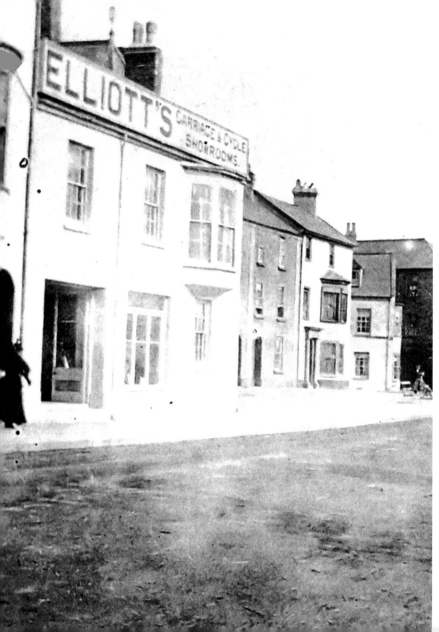

10. THE QUAY III

The openness of the quay area is well displayed in this photograph – the result of many extensions over the centuries. In this image from around 1900 we see a very different series of buildings to today. The large Manor House is still present while the BARC clubhouse is being used as a warehouse and today's Nationwide has replaced Elliott's Carriage & Cycle Showrooms. The workmen in the image are laying the rails for the Bideford–Westward Ho! railway illegally (the Appledore extension came later).

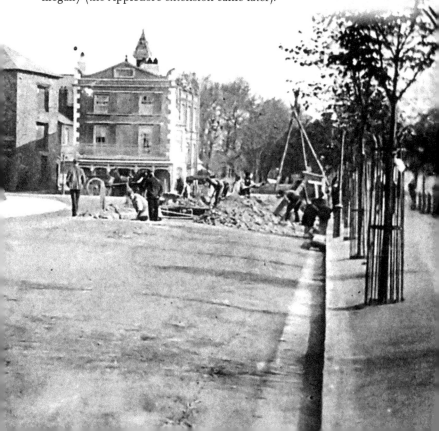

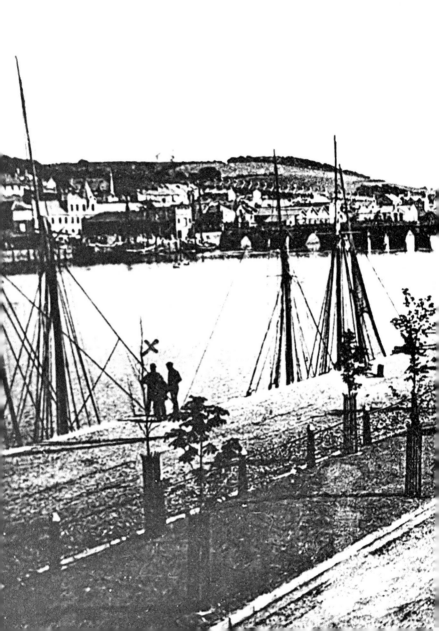

11. THE QUAY IV

Here is the quay in around 1895 with freshly planted trees and no railway lines yet laid. The old trees were replaced several years ago, but the boats and the bridge are still there – enduring features of Bideford and long may they remain.

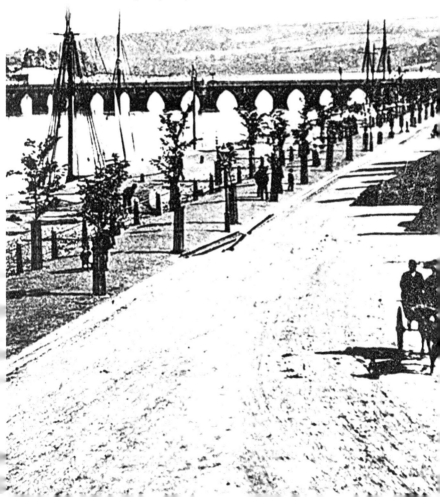

12. BIDEFORD, WESTWARD HO! & APPLEDORE RAILWAY

We couldn't publish a book like this without mentioning the Bideford, Westward Ho! & Appledore Railway. Opened in 1901, and closed in 1917, the little line came right along the quay and into the heart of the town, as shown by this photograph.

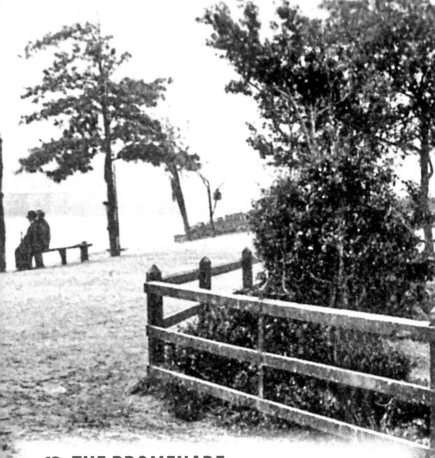

13. THE PROMENADE

This was the Kingsley Statue end of the quay before 1900. The small bridge crossed over the Pill stream in front of today's Art School, which was filled in to allow construction of the Bideford–Westward Ho! railway. It is very different today and one would be hard pressed to know a stream ever existed here, let alone a bridge.

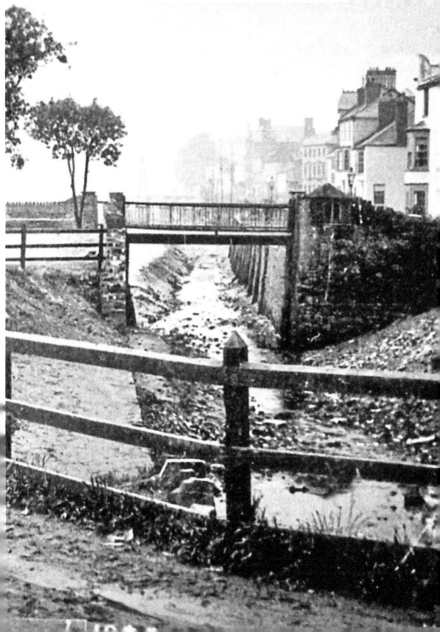

14. BRIDGELAND STREET I

Given its width it is hardly surprising that Bridgeland Street has often hosted public events, with the town carnival always drawing crowds at this particular point. This late 1960s photograph shows some sketchy Christmas decorative lights as well as the old building on the corner on the left.

15. BRIDGELAND STREET II

Bridgeland Street owes its existence (and grandeur) to the Bridge Trust who, around 1690, began to develop a jumble of old houses, sheds and riverside yards into a new street. The first was built in 1692. Daniel Defoe visited around 1704 remarking it was 'broad as the High Street of Exeter, well-built, and which is more than all, well inhabited, with considerable and wealthy merchants, who trade to most parts of the trading world'. This image is from around 1910 and there has been little change to the area since then.

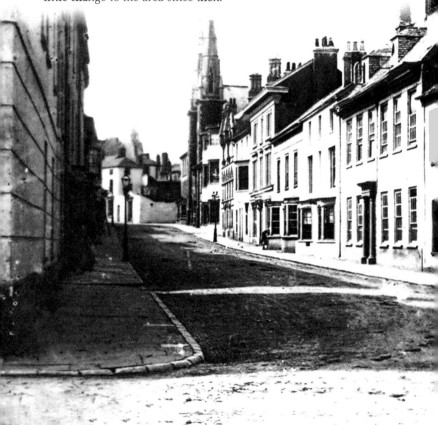

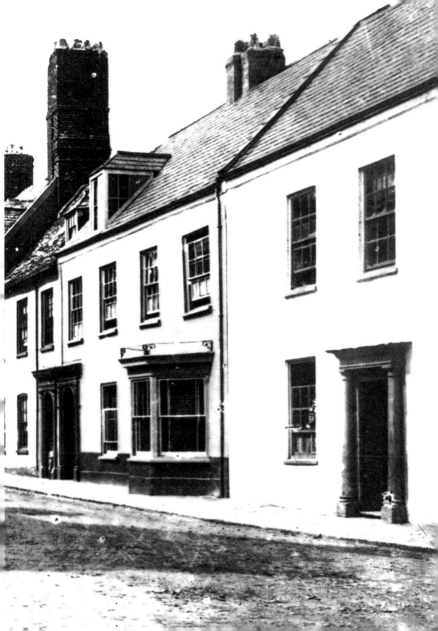

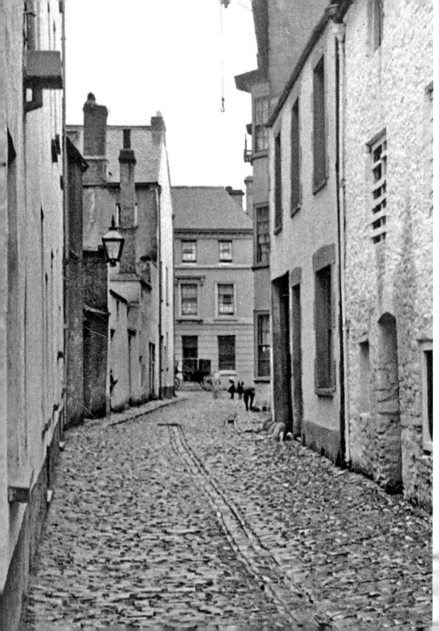

16. QUEEN STREET

Queen Street once marked the edge of the quay, which explains the presence of some grand buildings here. This image, shot from the 1890s, shows a cobbled road lined with warehouses and a building that preceded Heard's Garage, which began life as a coach building business. The present-day HSBC can nowbe seen at the end of the street.

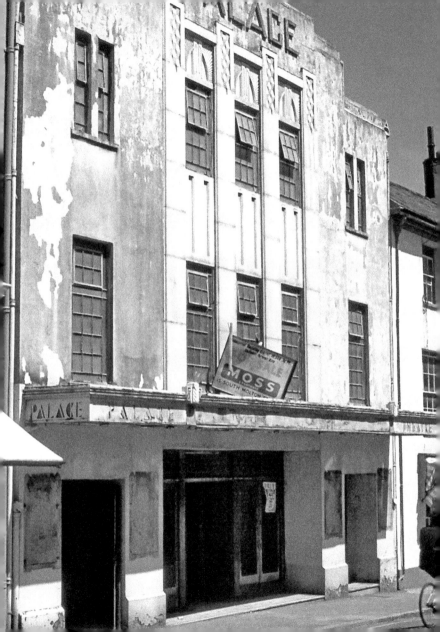

17. BRIDGELAND STREET III

Bideford has had five cinemas although only one remains. This photograph shows the Palace cinema in Bridgeland Street, which thrived for many years before being killed off by the new-fangled television. The building was demolished and replaced by a 1960s 'brutalist' supermarket run under the name of Ford & Lock, which in turn became the Bideford Carpet & Furnishing Centre, though recently it has become a Wetherspoon's public house.

18. BRIDGELAND STREET IV

It takes a little while to recognise where this *c.* 1900 photograph was taken although you should be able to place it from the chimneys and roof line if nothing else. The top of Bridgeland Street had a very narrow and sharp turning into Mill Street and when it was rebuilt the opportunity was taken to round off the 90-degree bend into a wider access.

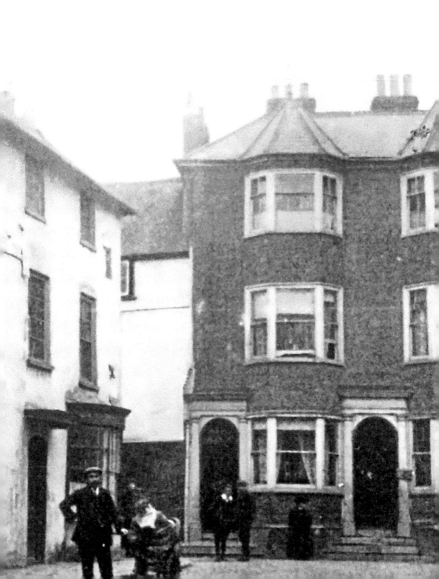

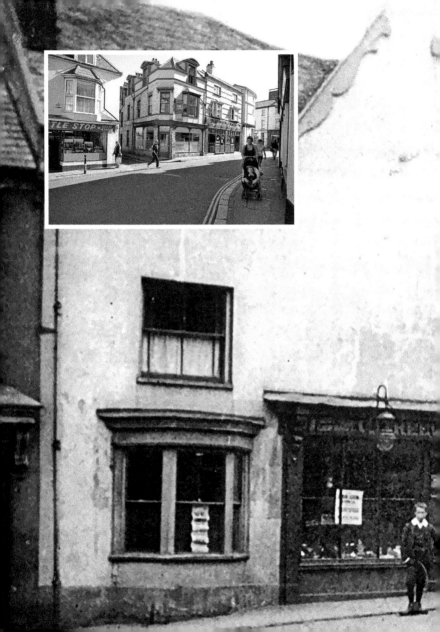

19. ENTRANCE TO WILLET STREET

It is only the presence of the twin spires of Lavington glimpsed over the roofs in this *c.* 1900 photograph that really identifies this shot. The entrance to Willet Street is in the centre and this is still here over a century later, as seen in the inset. In the intervening years all the shops either side of Willet Street have been totally rebuilt to house an off-licence, accountancy firm and a fish and chip shop – one of the more dramatic changes in the town perhaps?

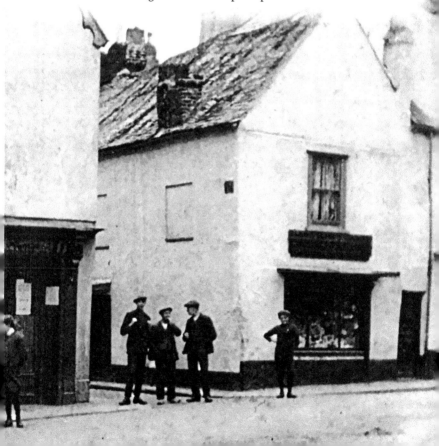

20. MILL STREET I

This building was purpose-built as a coach-builder's workshop, as shown in this photograph from around 1910. The confidence of the owner comes over well and one can only admire the skill displayed in the brick detailing on the frontage. Note that the photograph features one of those ornate gas lamps apparent in other shots from around this date.

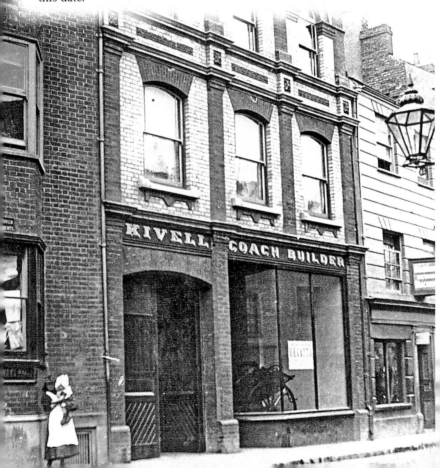

KIVELL, COACH BUILDER

21. SWAN PUBLIC HOUSE

The tiny Swan public house in Mill Street is shown in this early 1970s photograph. Such small pubs were the first to go as public drinking habits changed, and Bideford, once known as the Pack of Cards for its fifty-two licensed premises, has seen a massive shrinkage in such places. Today, the Bideford Café occupies the site with new windows. The beautiful curved glass front to the tiny shop on the left is still there though Derek's Hairdressing Salon has long gone.

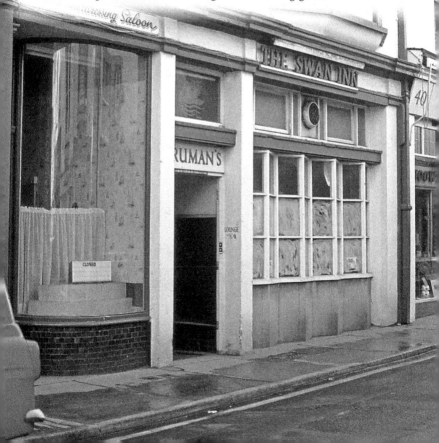

22. MILL STREET II

This is the end of Mill Street where it meets Bridgeland Street. The curved building at the junction is still recognisable today but everything else has changed. The extravagant wall painting for the Swan public house has gone and all the buildings to the right have been rebuilt as has the one next to the building with the curved frontage. A colourful florist's business now occupies the shop at the end.

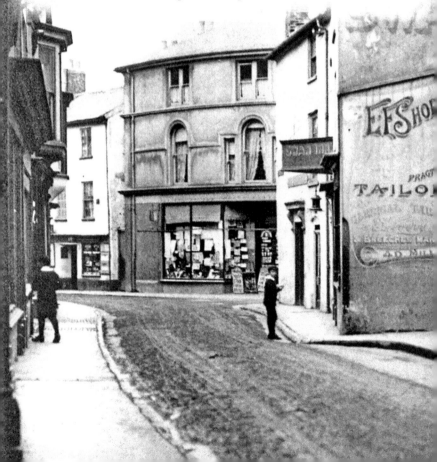

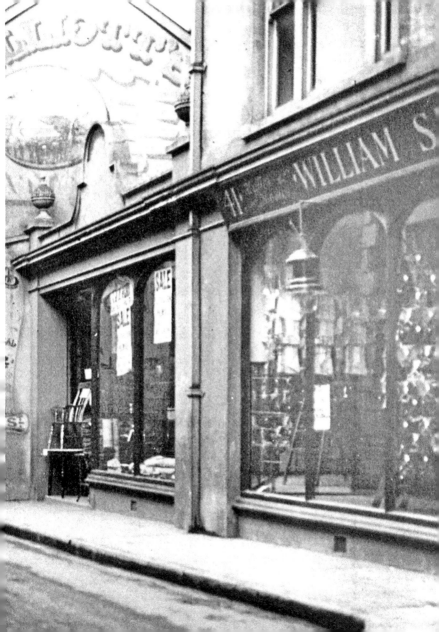

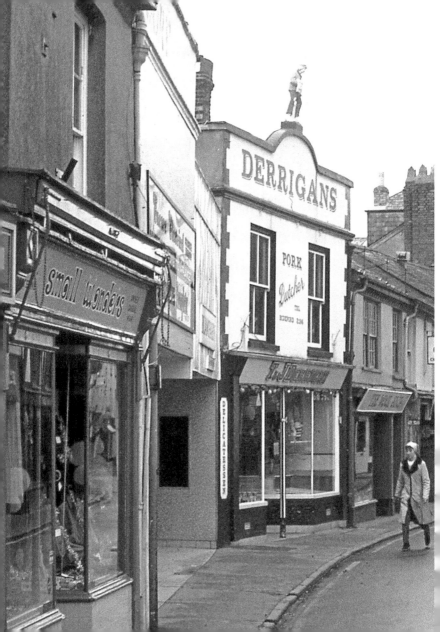

23. MILL STREET III

Another view of Mill Street from the other direction, taken in the 1970s. The very narrow and sinuous nature of the road comes over well here. The old kerbs and pavements have now gone and been replaced with varicoloured brickwork which may be soon changed again.

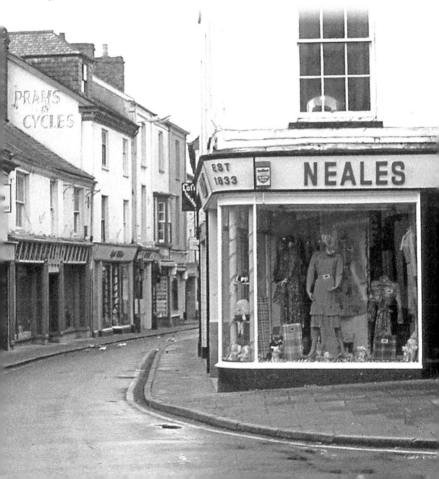

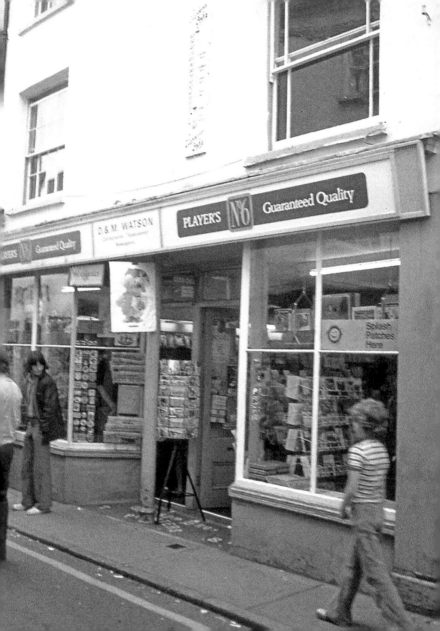

24. MILL STREET IV

Watson's news agency still exists in the High Street but here was an earlier incarnation from the early 1980s in Mill Street, with the usual rotating postcard stand and racks of paperbacks just visible. The windows may have changed of the WHSmith store that is now in the shop, but the old public thermometer, advertising Stephen's Inks, is still in place with its very optimistic top reading of 140 degrees Fahrenheit.

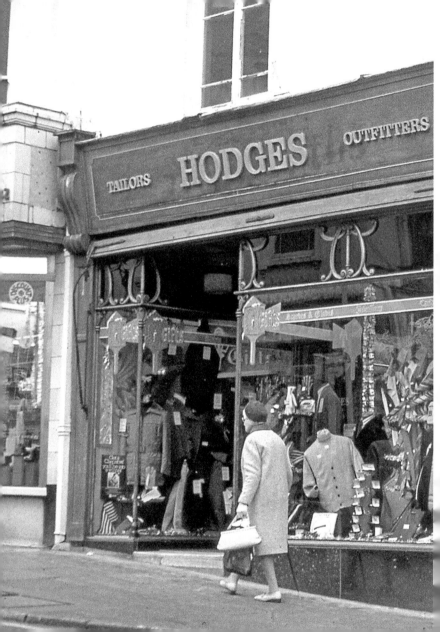

25. JUNCTION OF MILL AND HIGH STREET

The junction of Bideford's two main shopping thoroughfares, Mill Street and High Street, is seen here around 1980. This is perhaps the busiest corner in town which makes it odd that so many different shops have come and gone over the years. The corner of the old Curry's shop, glimpsed to the left, is another store that has left our High Street and gone to out-of-town megastores.

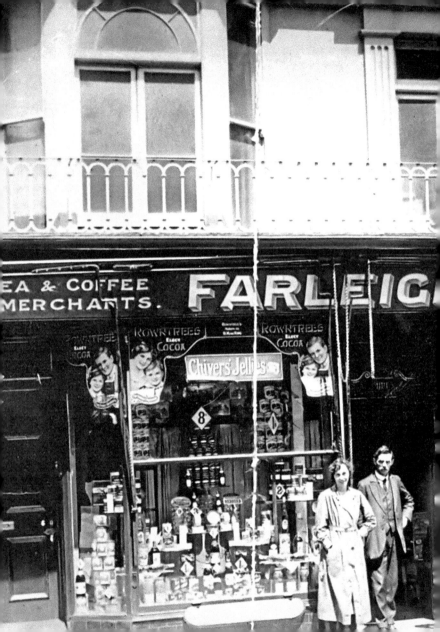

26. FARLEIGH'S GROCERY SHOP

Only by looking at the windows above the shop fronts will you recognise this building as today's New Look. The 1920s shop front of Farleigh's grocery shop is shown here with its proud staff standing in front.

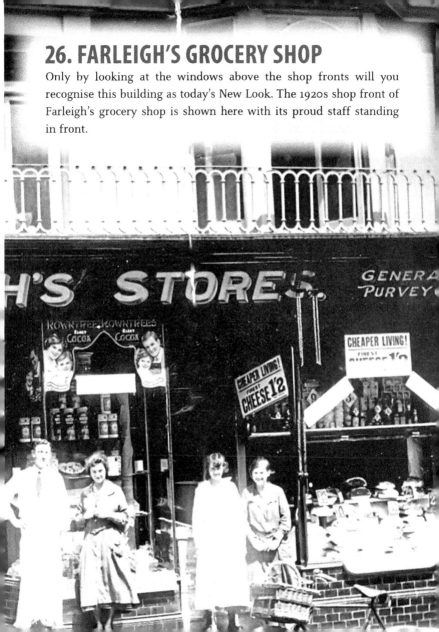

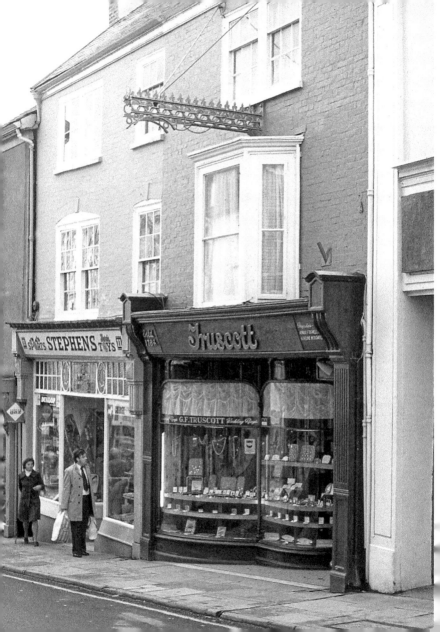

27. SMALL BUSINESSES

Bideford is lucky in that it still has many small businesses. Many may be struggling to survive but they are still here, often in buildings with wonderful frontages. These two High Street shops, Stephen's toyshop and Truscott's jewellery shop, are pictured here in the early 1970s. Currently there today is Walter Henry's bookshop and a charity shop; the former still utilises the beautiful curved Edwardian windows.

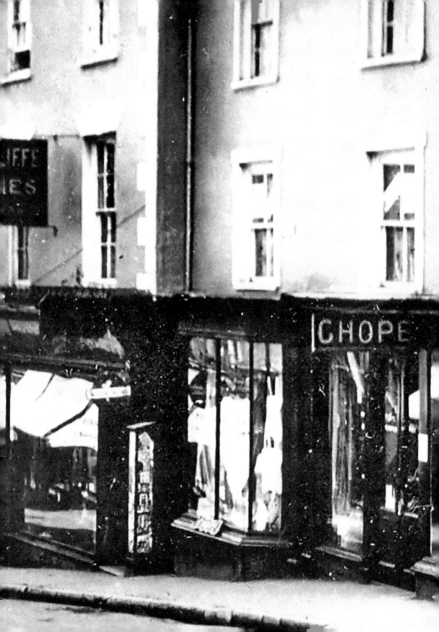

28. THE CHOPE FAMILY

The Chope family have long been associated with Bideford, most famously as drapers in the High Street. Their large premises dominated the area for many years with the shop frontage being regularly updated to reflect new fashions in architecture. This photograph shows the shop in the 1920s. Today, the family still run Walter Henry's bookshop next door.

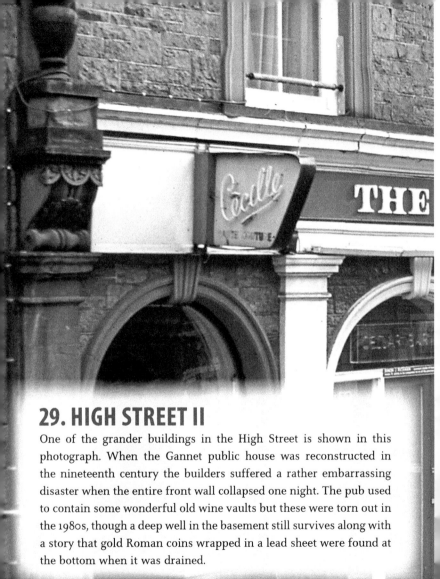

29. HIGH STREET II

One of the grander buildings in the High Street is shown in this photograph. When the Gannet public house was reconstructed in the nineteenth century the builders suffered a rather embarrassing disaster when the entire front wall collapsed one night. The pub used to contain some wonderful old wine vaults but these were torn out in the 1980s, though a deep well in the basement still survives along with a story that gold Roman coins wrapped in a lead sheet were found at the bottom when it was drained.

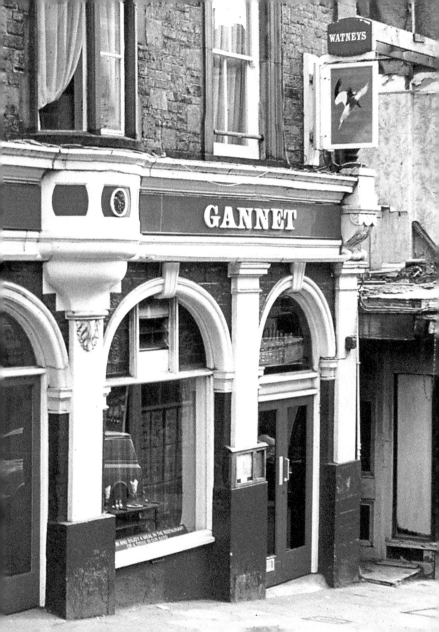

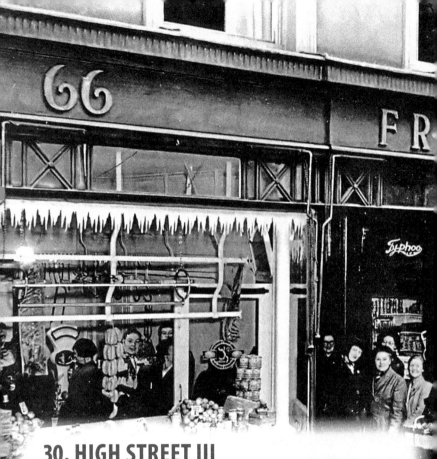

30. HIGH STREET III

As supermarkets have grown smaller shops have disappeared and the street scene has changed. This image, from around 1948, shows a large queue of mainly female shoppers waiting to get into Frayne's grocery/ butcher shop. The shop later went through many incarnations, including a second-hand record/bookshop that I ran in the 1980s before it was completely refurbished into flats.

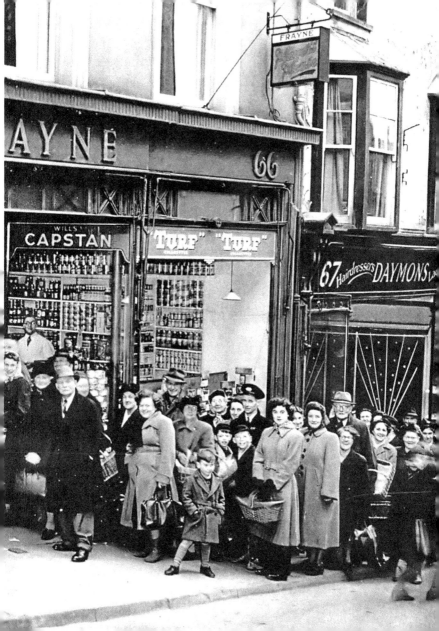

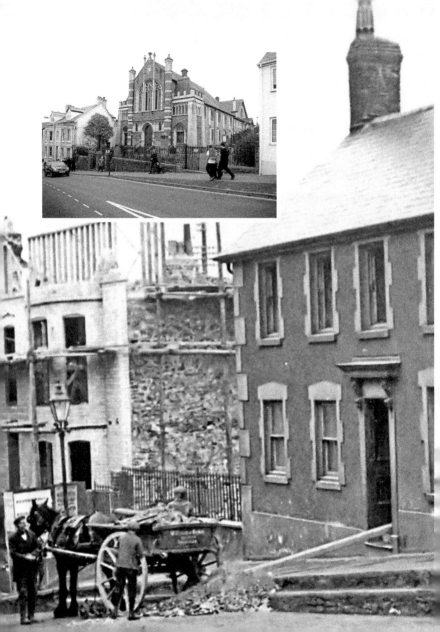

31. METHODIST CHAPEL

The astonishingly grand Methodist chapel in the High Street dates from 1913 and here we see the site prior to its construction. The houses to the left, still extant today, are under construction whilst the corner of the house to the right is the same in both shots. The curious double-step pavement curb has been filled in to provide a sloping edge, visible in the inset which was taken in 2012. The contrast in clothing between the Edwardian and early twenty-first century children is striking – Eton collars and caps replaced by T-shirts and trainers.

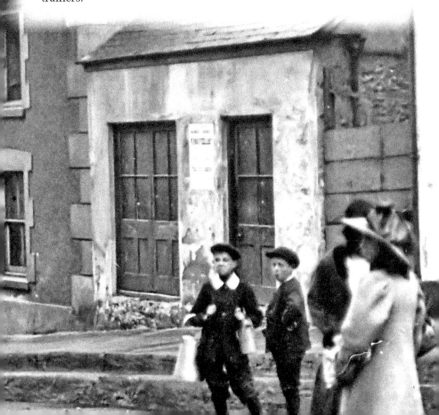

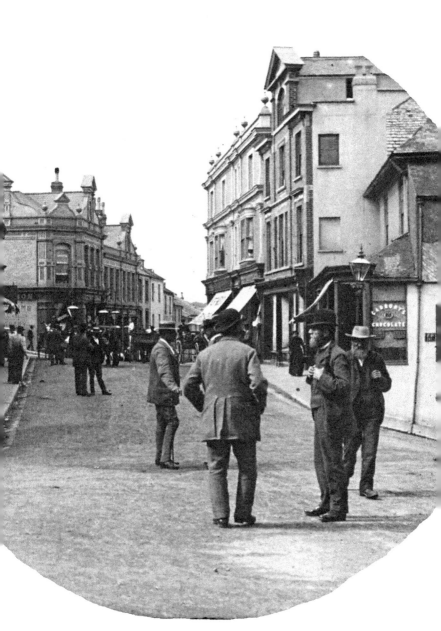

32. MARKET PLACE *c.* 1905

Market Place is seen here with some well-dressed gentlemen casually chatting in the road. This part of town used to be the trading hub on Tuesdays and Saturdays when local farmers came to Bideford to conduct business while their wives would bring hampers or panniers of fresh produce to sell in the Market Hall. Today, the scene is still recognisable apart from the 'new' (1920s) art deco white building located in the centre that was built for a local building society and is now a private house.

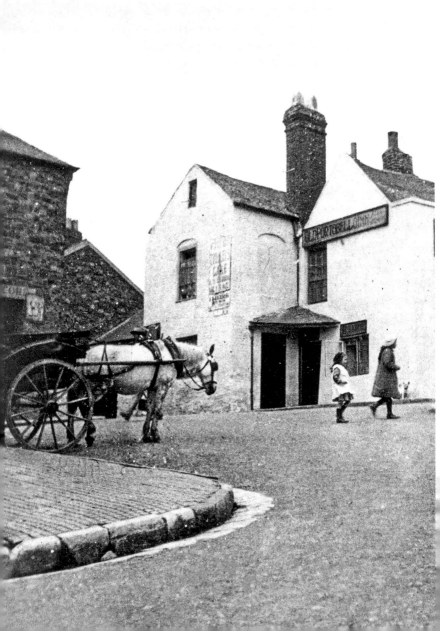

33. THE PORTOBELLO INN

The Portobello Inn is one of the last survivors of the numerous pubs that lined the Market Place, catering to the thirst and hunger of country dwellers who had travelled into town to buy and sell. The horse and cart have now given way to the car and new doorways and windows have been inserted into the building, but the scene is still easily recognisable today.

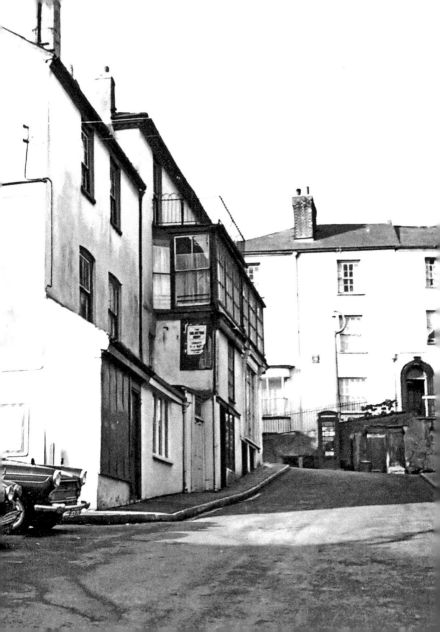

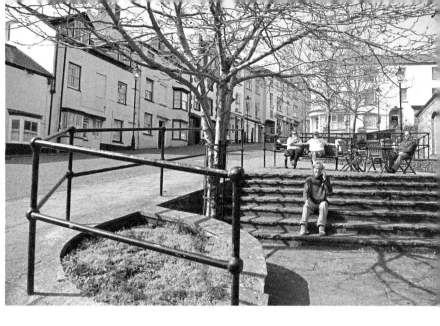

34. PANNIER MARKET

One of the most changed views in this collection is shown here. Up until around 1980 the area next to the Pannier Market was filled with this old building. Its final use was as a Salvation Army Citadel. During its demolition a very rare seventeenth-century wall mural was discovered in the basement which was rescued and is now on show in the Burton Art Gallery and Museum in town. The 2012 image above shows a landscaped area with outdoor seating for the Market Café.

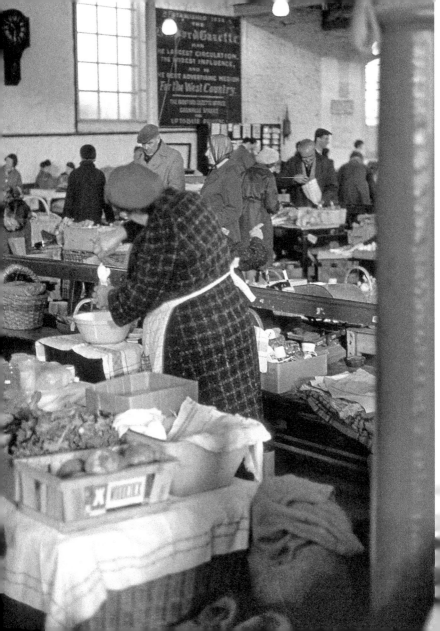

35. BIDEFORD PANNIER MARKET HALL

Bideford Pannier Market Hall dates from 1883 when the town council rebuilt the old run-down structure. This provided a covered hall for local people to sell produce and other items. This photograph, from 1969, shows one of the stallholders ladling clotted cream into a jam jar. The old-style panniers have now gone but the market traders still attend on Tuesdays and Saturdays throughout the year.

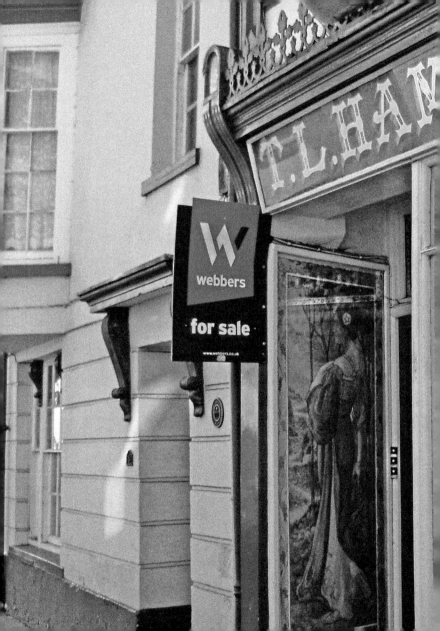

36. THE ART NOUVEAU PAINTING IN BUTTGARDEN STREET

One of the greatest treasures of the town is a very striking art nouveau painting. This does not hang in our art gallery, however, rather it is to be found tucked inside the doorway to a house in Buttgarden Street. The building, which shows many features of the Arts and Crafts movement, was once owned by T. Hamlyn, who ran a flourishing decorating business. To display his skills, he erected a gilded sign over his shop window, installed an intricate mosaic bearing his name as a doorstep and produced the painting that exists today. The building is listed, which means that the painting cannot be removed. It is now protected by a heavyweight glass panel – still giving pleasure to those who have grown up with it or who unexpectedly stumble across it.

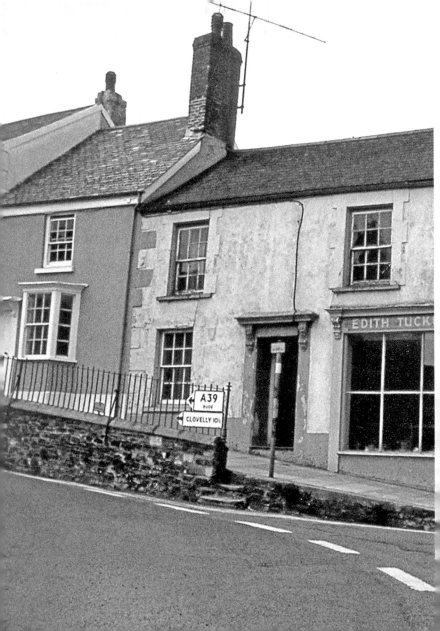

37. JUNCTION OF MEDDON STREET AND BUTTGARDEN

The junction of Meddon Street and Buttgarden is seen here, with the corner store of Edith Tucker visible. Today, the shop fronts on both sides have gone, replaced by domestic windows designed to fit in with the existing building pattern. The houses belong to the Bridge Trust which is one of the biggest property owners in the town and probably originated some 700 years ago when the bridge was built.

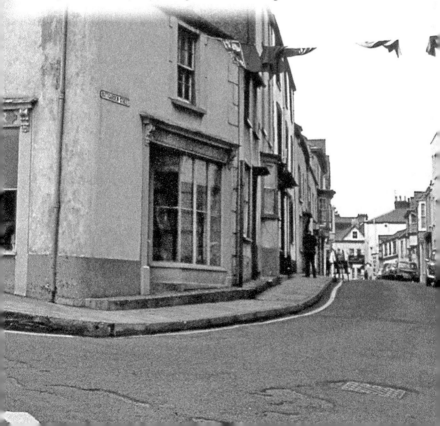

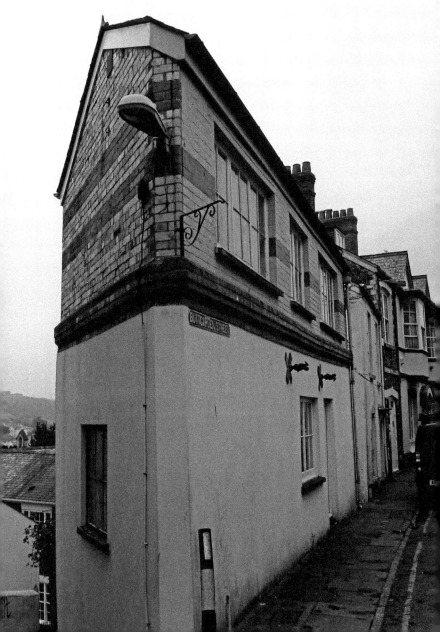

38. THE 'TRIANGULAR' HOUSE

At the top of Tower Street and fronting Buttgarden Street is the oddest-shaped house in Bideford, it being virtually triangular. Little is known about this three-storey house but it appears on an 1842 map with a 'square' shape – so it has been added to at some time.

39. TOWER STREET

Tower Street is a real mix of houses both in date and appearance. On the right as you look up the street are small eighteenth-century or earlier cottages, on the left are some early nineteenth-century houses with patterns worked in coloured bricks which then give way to a large Georgian house which at some time was split into two, thus destroying its symmetry. Note, however, the presence of the largest door-knocker in Bideford on this house. Go up a little further and one of the smallest houses in town is seen – with a rare example of sideways-sliding sash windows. They are, in fact, modern replicas but they do represent what most windows would have looked like in the past. In this image, from 1911, the flags are out to celebrate the coronation of George V. Note the proud lad in his 'go-kart'. A century later the cobbles are still present, with added flagstones whilst the varied mixture of house styles is as attractive as it ever was.

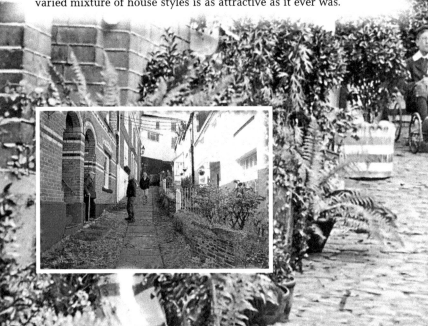

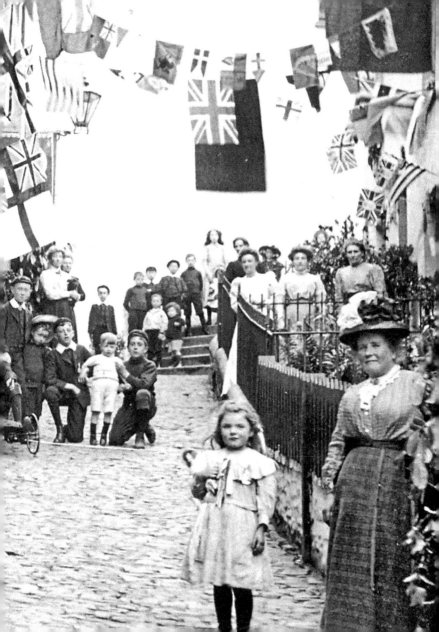

40. 4TH VOLUNTEER BATTALION OF THE DEVON REGIMENT

The men of the 4th Volunteer Battalion of the Devon Regiment shown here were the descendants of the Bideford Rifle Volunteers first formed in 1859 to repel a threatened invasion by the French. They are seen here marching through the gates of St Mary's after a church service. The inset image shows the Bideford Town Band similarly marching through the now rather less ornate gateway at St Mary's after playing at a civic service.

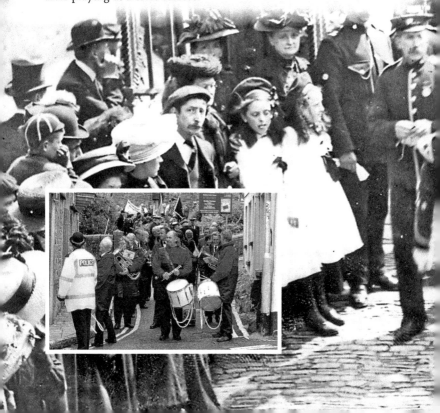

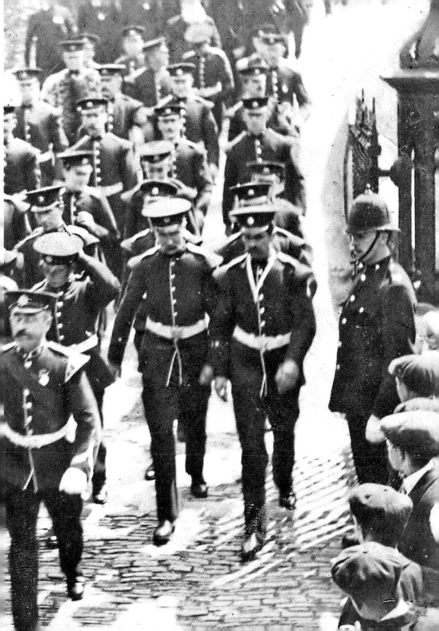

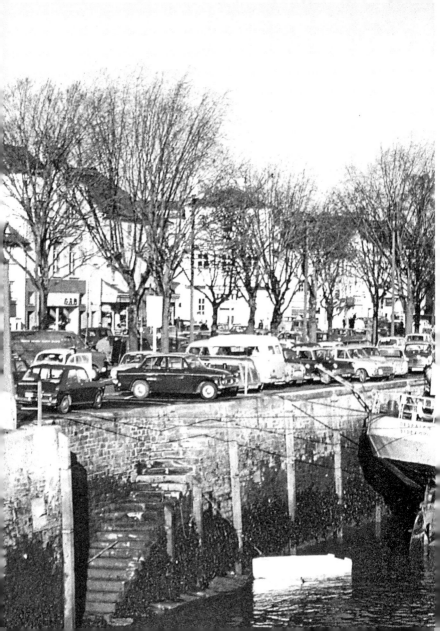

41. THE QUAY V

Today the port is looking for new cargoes to keep it profitable and busy. This image shows the area around forty years ago, yet the number of cars parked on the quay does not seem to have changed much compared to today, even if their designs have. The old trees visible were replaced a few years ago by new ones when the entire quayside was extended 18 feet and a new parapet put in place.

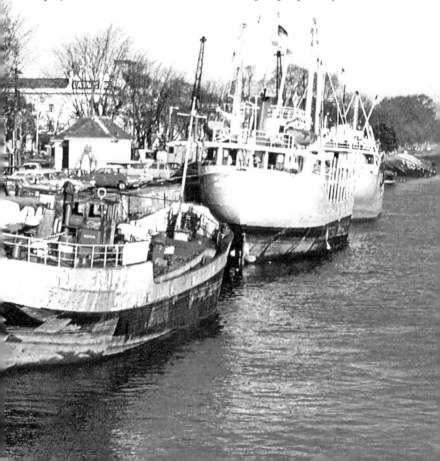

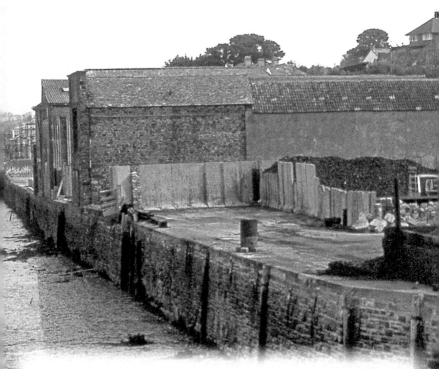

42. THE QUAY VI

The quay provided the main harbour facilities in Bideford, but those at East-the-Water were also important. Seen here around 1970 they were notable for their large coal stores and warehouses. In October 1972 most of these old buildings were demolished and those that weren't are now empty.

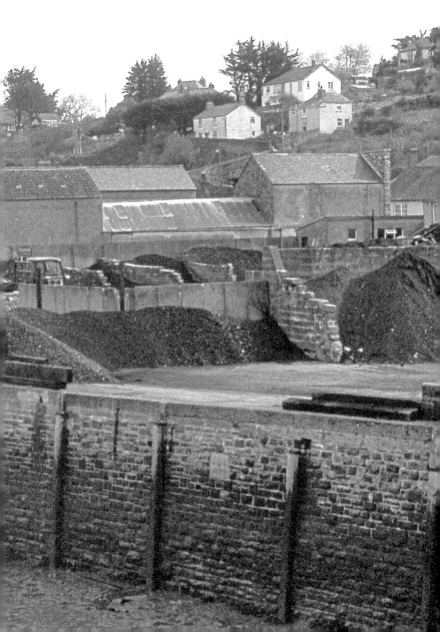

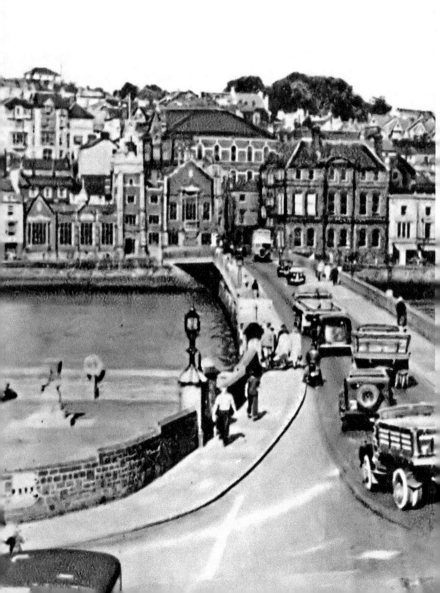

43. BIDEFORD BRIDGE

Taken from the railway station, this would have been the first view many people would have had as they arrived in town. In this 1950s shot, traffic is just as heavy as it is today, highlighting the importance of the bridge to the town and to the local transport network. It also shows what a glorious setting Bideford has and how lucky its inhabitants are to live here.

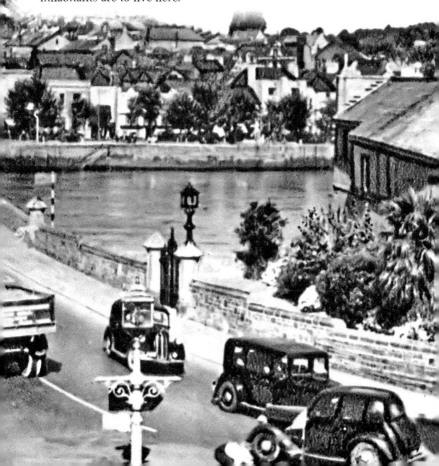

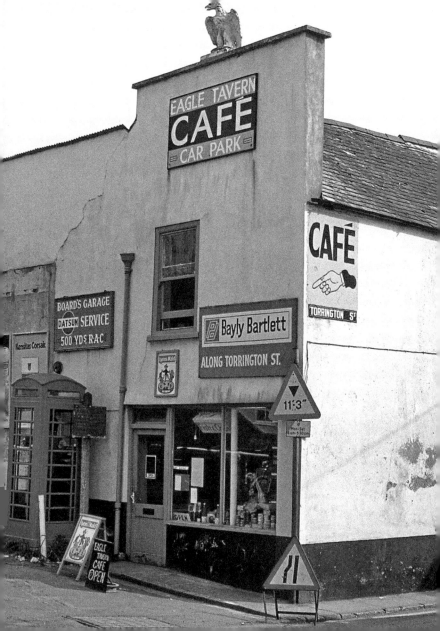

44. TORRINGTON STREET

This 1960s photograph shows the Eagle Tavern Café which used to stand in Torrington Street opposite the Royal Hotel. It later became a dog-grooming parlour and then a private house before being demolished; the site was later incorporated into the hotel's car park.

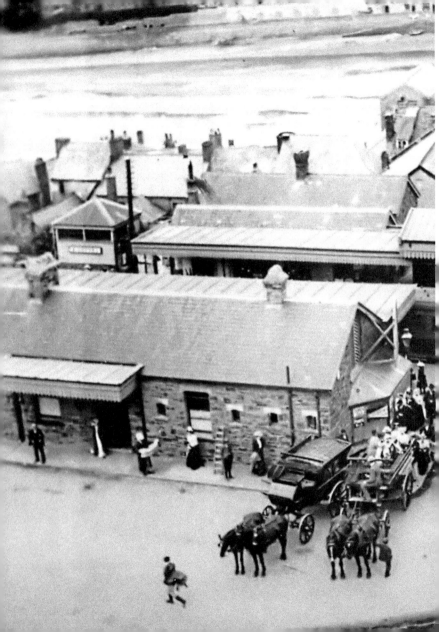

45. BIDEFORD STATION

The railway station taken from the hill above – a favourite vantage point for photographers over the years as is clear from the Edwardian example reproduced here. The collection of waggons testifies to the importance of the old rail system. Today, the railway yard has become a car park and Bideford's sobriquet of 'The Little White Town' (taken from Kingsley's *Westward Ho!*) is still applicable with many buildings facing the river painted in that colour.

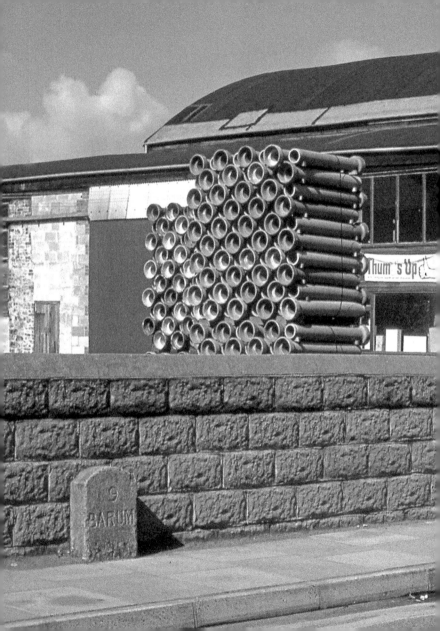

46. BUILDER'S MERCHANTS

All things change and perhaps not always for the better. This image, from around 1970, shows the premises of Devon Trading, a builder's merchant that once occupied a great swathe of the wharves at East-the-Water. Sited here to unload material directly from small coasting vessels, it closed and its buildings were cleared with the area becoming tarmacked by Torridge District Council to provide a car park.

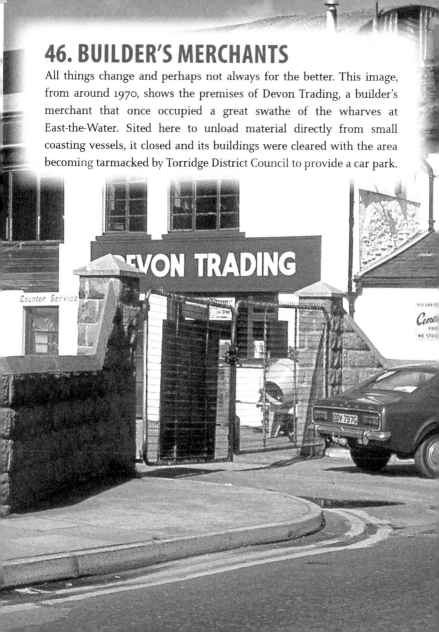

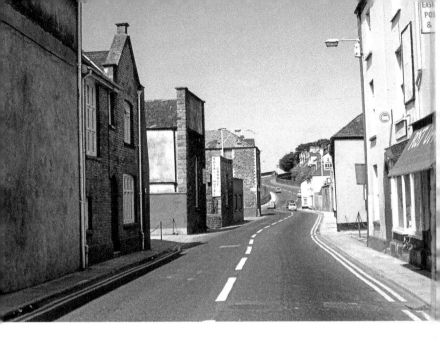

47. BARNSTAPLE STREET

Up until 1987 the Long Bridge was the lowest bridging point of the Torridge. The main access was via Barnstaple Street, which was widened in the 1920s to allow for motor traffic. It is shown here in a 1960s photograph when the large warehouses that used to line the East-the-Water bank were still in place.